THE LIBRARY OF
TRINITY COLLEGE DUBLIN

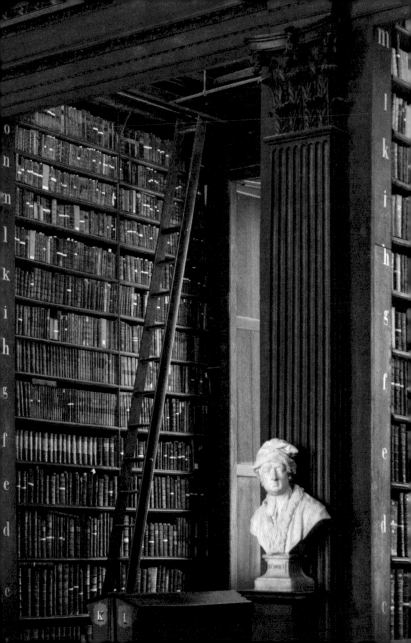

POCKET PHOTO BOOKS

THE LIBRARY OF TRINITY COLLEGE DUBLIN

HARRY CORY WRIGHT

INTRODUCTION BY HELEN SHENTON

Thames & Hudson

INTRODUCTION

HELEN SHENTON

I first stepped onto the balcony of the Long Room – frequently described as 'the most beautiful room in Ireland', and often called the 'most magnificent library in the world' – early one summer morning as the soft, dust-speckled sunbeams radiated diagonally across the room. Cleric and historian Gerald of Wales (1146–1223) described the Book of Kildare (an early medieval Gospel manuscript – now lost – that is believed to have been similar to our Book of Kells) as 'the result of the work, not of men, but of angels'. On my first visit to the Long Room, it felt as if such ethereal beings might gently float down the early morning shafts of sunlight.

It was my first week as Librarian and College Archivist – the first woman to hold the position since Queen Elizabeth I founded Trinity College Dublin in 1592. The Head of Security and I entered the Old Library through the labyrinthine underground passageways connecting the 18th-century Old Library to the 20th-century Berkeley Library near by. Looking down at the 200,000 volumes in the handsome, dark, oak bookcases in the soft morning light, I was profoundly moved by the beauty, the stillness, the history, the accumulation of knowledge … and by my responsibilities. My companion, who had been working in the library for many years, quietly confided that every day the view of the Long Room still moves him deeply.

The Long Room's beauty and its overwhelming assault on all the senses have a visibly visceral effect on people. I have seen hard-bitten property tycoons choke back a tear on entering

the Long Room for the first time. Many visitors walk in, stop dead in their tracks, take in the arc of the cathedral-like proportions and exhale a hushed 'wow'.

It is the soaring, barrel-vaulted ceiling that reinforces the cathedral-like quality of the Long Room. In the spirit of Trinity's long tradition of innovation, this exquisitely curved vault was a radical and inventive engineering solution to a prosaic 19th-century problem – namely, an insecure roof. It also enabled the urgent need for extra space to be resolved by the addition of more bookshelves. The new barrel-vaulted ceiling was completed in 1861, nearly 150 years after the foundation stone of the Old Library was laid in 1712. The outer shell was built by 1723 and the original library was completed in 1732 – the first building at Trinity constructed for the specific purpose of teaching.

The Long Room was designed to be on the first floor to protect the books not only from rising damp, but also, it is thought, from underground streams. The ground floor, with its elegant arches and imposing internal columns, originally consisted of an open arcade on either side, separated by a central spine wall. On one side was the private Fellows' Garden and, on the other, a square completed by three residential buildings.

The impetus for building the 'New' (now 'Old') Library was lack of space for the existing books, but there was also a need to provide room for readers and academic purposes. The building was funded through three grants of £5,000, each voted by the Irish Parliament in 1709, 1717 and 1721.

From the beginning, the Long Room has inspired admiration and respect. In 1777, the lawyer and cleric Thomas

Campbell described it as 'a most superb library ... The inside is, at once, beautiful, commodious, and magnificent.' In 1799 the artist James Malton wrote:

> On entering this extensive Library, we are instantly struck with unspeakable reverence, and respect for the place; as if feeling the air impregnated with an emanation of Religion and Learning; and involuntary emotions cause us to acknowledge our littleness and individual insufficiency, when in the presence of the united efforts and condenced [sic] learning of our ancestors, who, with calm serenity, seem here to reign in awful silence: 'tis scarcely possible for the most boisterous and unthinking to enter, but with silent humiliation, and whispering enquiry.

It is clear that the strong emotional response to the Long Room was aroused from the beginning, and it is one that is accentuated by the senses. I am struck by how many of our visitors – especially younger people – comment on the smell of the books and their liking for it. The sweet note is attributable to furfural, the smell from ageing cellulose in paper; it is similar to the smell of almonds, which contain the same chemical.

Equally noticeable is how people lower their voices when in the Long Room; they sit and contemplate the soaring space. In an increasingly digital and virtual world, I find it striking how appealing such an 'immersive', quintessentially physical experience of the Long Room is. I was recently at the Anne Frank House in Amsterdam, where a similar number of about a million visitors experience a world-famous book, *The Diary of Anne Frank*, in a totemic, special space. In conversation with

the director, I discovered that, somewhat counter-intuitively, we are both witnessing the same, strong desire from our visitors for an all-embracing, all-enveloping, all-encompassing physical experience in a digital age.

The impact of the Long Room is due in no small part to it remaining, essentially, a working, living library. The collections are consulted: volumes are retrieved from the shelves (via the tapering ladders) and delivered to readers in the reading rooms, located out of view at either end of the building.

The books include named, foundation collections such as that bequeathed by James Ussher (1581–1656), Archbishop of Armagh (probably best known for his deduction that the world was created in 4004 BC). His collection, elegantly acknowledged in gold lettering on the frieze running over the alcoves, includes the first edition of Miles Coverdale's translation of the Bible in 1535, and Ptolemy's *Geographia* printed in Rome in 1490 and therefore an incunabulum (a beautiful word describing a book printed before 1501, in the early days of Western printing). Incidentally, James Ussher's brother, Ambrose Ussher, was appointed the first Keeper of the Library in 1601, on a salary of £2 5s. per year.

The Long Room contains an extraordinary wealth of material – from the richly illustrated Nuremberg Chronicle of 1493 to Colen Campbell's rare edition, dated 1728, of Andrea Palladio's *First Book of Architecture*. There are exquisite natural history drawings and stunning maps, such as those illustrated in the following photographs, from Mark Catesby's *The Natural History of Carolina, Florida and the Bahama Islands* (1731–43), and Joannes Jansson's *Atlas Contractus* (1666).

Jansson's atlas is from the astonishing Fagel Collection, which was effectively the working library of the prime ministers of the States General of the Netherlands for more than a century. It came to Trinity in 1802 through Hendrik Fagel, a refugee in London, who was forced to sell it. This pan-European collection remains largely intact. The stories about the books, their authors, their creation, their composition and their history of how they came into the Long Room are as fascinating as the texts between the covers.

The gallery above the alcoves was not designed originally for books, as it was empty of shelving until the 1840s. The gallery is reached by one of three staircases – two of wood and one iron spiral staircase. The vertiginous, wooden, open-well staircases seem almost to speak and breathe as they creak with every ascent and descent. The view down through each stairwell is remarkable. Once upstairs, I especially love the enfilade of book bays viewed through a succession of perfectly aligned doorways on either side of the gallery. Barely glimpsed from below, the photographs in this book capture this magnificent, diminishing sense of perspective.

The gallery has since filled up. First, the large bookcase housing the collection of volumes bequeathed by Henry George Quin sits proudly at one end, overlooking the Long Room. A graduate of the university, he died in 1805, committing suicide at the age of 45 and leaving a note to say that he was tired of living. Quin requested that the books be kept in the bookcase and that they never be rebound or have letters stamped on them. The 110 titles were purchased during Quin's travels in Europe – the 'grand tour'. The Quin Collection also includes fine bindings commissioned by the

great book collector Jean Grolier de Servières, Viscount d'Aguisy (1489/90–1565) as well as a binding executed by Edwards of Halifax. The latter specialized in bindings with paintings underneath transparent vellum – the result of consummate craftsmanship and skill. There are also 17 incunabula in the Quin Collection; some of them are printed on vellum, as well as one printed on white silk.

An important development was the Copyright Act of 1801, whereby Trinity College was designated an Irish legal deposit library entitled to a copy of every book published in the United Kingdom (which then included Ireland). This led to an exponential increase in books coming into the library. Consequently, bookcases were constructed under the windows on either side of the gallery; these are ingeniously hinged at one end, enabling them to be swung out on metal tracks set into the floorboards, revealing additional bookcases behind. Most of the gallery still contains legal deposit material, and Trinity remains the UK legal deposit library for the island of Ireland, presently acquiring about 55,000 volumes each year. A fascinating challenge today is the development of the legal deposit of material that is published digitally, ranging from websites to electronic journals to e-books to geospatial maps. Libraries have always successfully reinvented themselves, preserving the best of the old while embracing technological and intellectual advances.

The notable non-book objects in the Long Room include a copy of the Proclamation of Ireland's independence, issued during the Easter Rising of 1916. A second copy of the Proclamation in the library's collection is particularly significant as a piece of Irish history. During conservation,

it was found to have been pasted over First-World-War recruitment posters outside the General Post Office, where the Easter Rising took place.

Also on display is Brian Boru's harp. No longer thought to have belonged to the medieval king but still named after him, the harp, made of willow with brass strings, probably dates from the 14th or 15th century. It is the model for the arms of Ireland; reversed, it is also the model for the trademark logo of Guinness.

Lining either side of the Long Room are 38 marble busts by sculptors including Peter Scheemakers and Louis-François Roubiliac. Represented are Classical writers and philosophers (such as Homer, Socrates and Plato), writers and scholars (including Shakespeare, Milton and Swift), Trinity College men (such as Ussher, Burke and Hamilton) and other prominent Irish figures (among them, Parnell, Plunkett and Delany). It is noticeable that there are no busts of women. As part of ambitious plans that include the conservation of the Long Room and the Old Library, Trinity College intends to amend this anachronistic anomaly.

Access to the library used to be restricted to Trinity's academic and postgraduate community. Fellows and Masters of Arts could, however, introduce 'strangers' to view the library's treasures, which were first put on display in the late 1830s. Queen Victoria was one such 'stranger' in 1849. Today, we are now welcoming almost one million visitors from every continent to visit the Book of Kells and the Long Room.

The Old Library has not only featured in films such as *Educating Rita* (1983) and *The Professor and the Madman* (2018), but was also George Lucas's inspiration for the Jedi

Archive in *Star Wars: Episode 2* (2002). Contrary to many comments made about the Long Room, it does not feature in any of the Harry Potter films.

The Old Library is where the nation brings its guests. Queen Elizabeth II came on her historic visit to Ireland in 2011, the same year that Michelle Obama and her daughters visited. During my time as Librarian and College Archivist, since 2014 we have welcomed the Prime Minister of France, the presidents of Germany, Italy and Kyrgyzstan, the First Minister of Scotland and Joe Biden, US Vice-President (who quoted from Seamus Heaney's 'From the Republic of Conscience', a moving poem commissioned by Amnesty International).

It is an enormous joy and privilege to welcome people for special occasions to the Long Room. One of my favourite annual events is the Bookmark Awards ceremony. The Bookmarks programme is a story-writing, illustration and bookbinding workshop for primary schoolchildren that uses the Pollard Collection (our outstanding collection of three centuries of children's books) as a stimulus for their own creativity. At the end of their two-month programme, the 70 schoolchildren, their teachers and their parents are invited to a celebratory event in the Long Room. The books they have created are displayed in this special place, at the very heart of the college. The excitement and wonderment of so many children is both inspirational and magical. The first year I presented the awards, I wondered if any of the schoolchildren from previous years had been inspired to study at Trinity by having their book shown in the Long Room. We searched the records … and we found him, a fourth-year medical student

who was the first of his family to go to university. When he received his award as a schoolchild in the Long Room he had vowed he would study at Trinity College.

At night, or in the depths of one of those dark, dour November afternoons in Dublin when all colour seems to have drained from the world, the Long Room is as moving as it is in the soft light of early morning. When all the people have gone and the doors are closed, the eye is drawn through the gloaming, along the lines of busts, to the 'darkness visible' and to the palpable sense of the infinite.

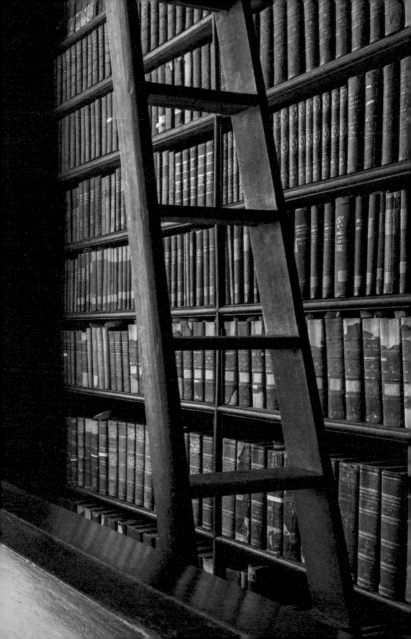

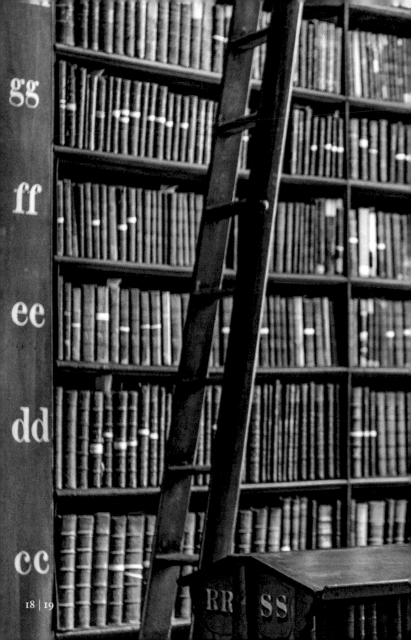

gg

ff

ee

dd

cc

RR SS

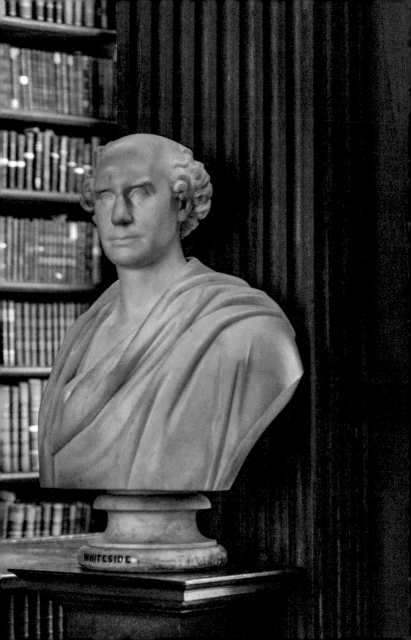

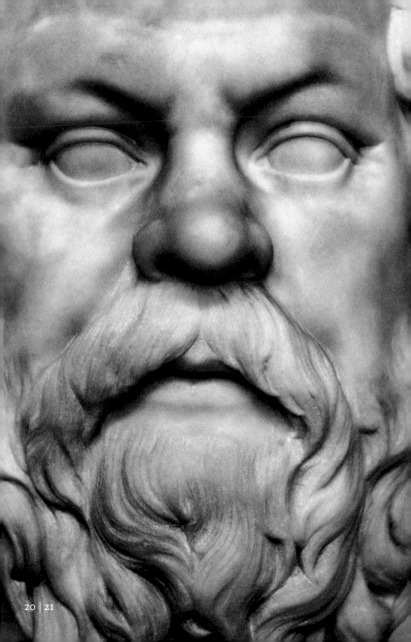

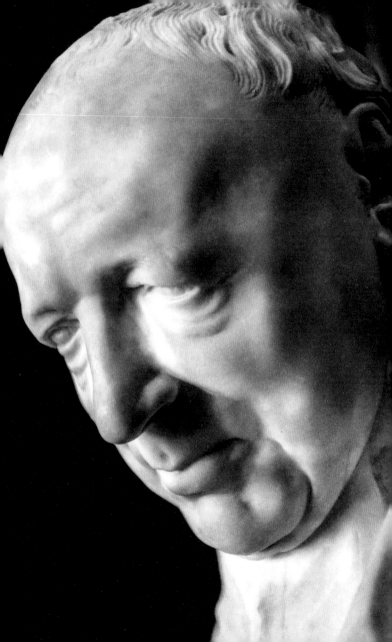

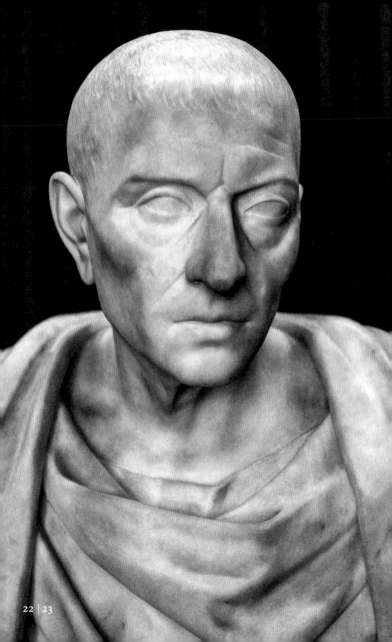

‘When I am alone all my conversation is with books.’

CICERO

Letters to Atticus

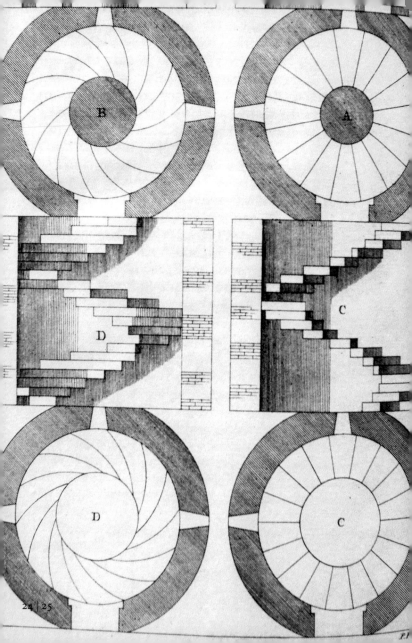

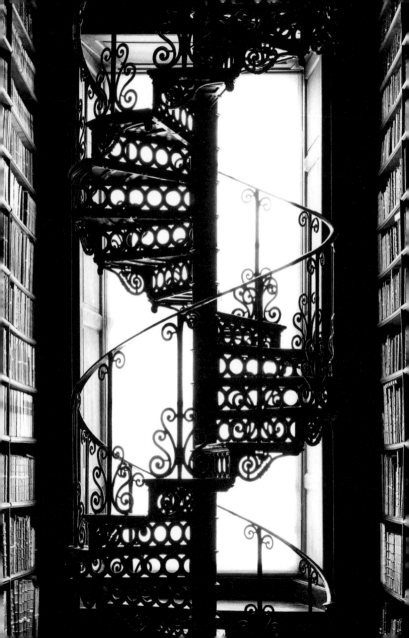

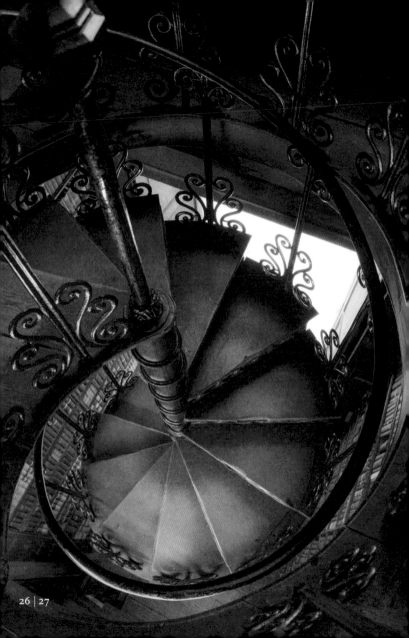

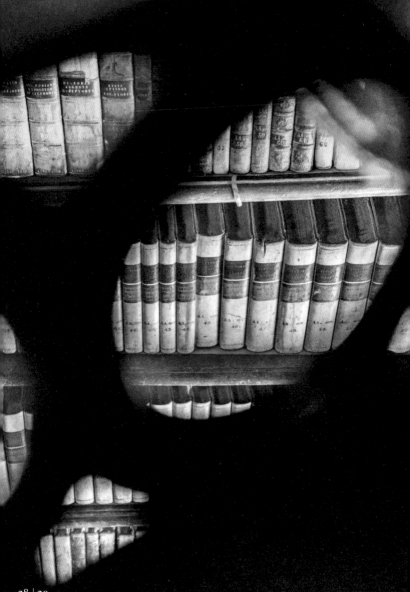

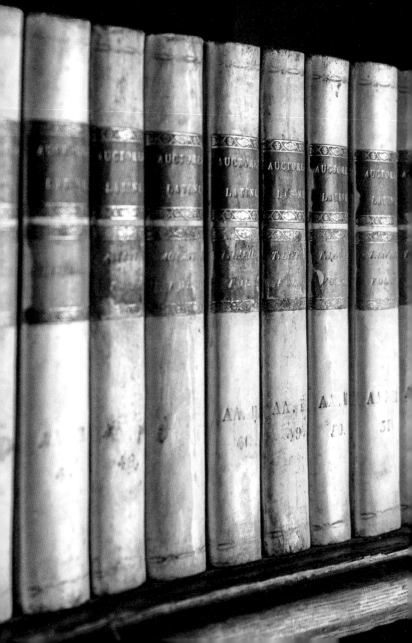

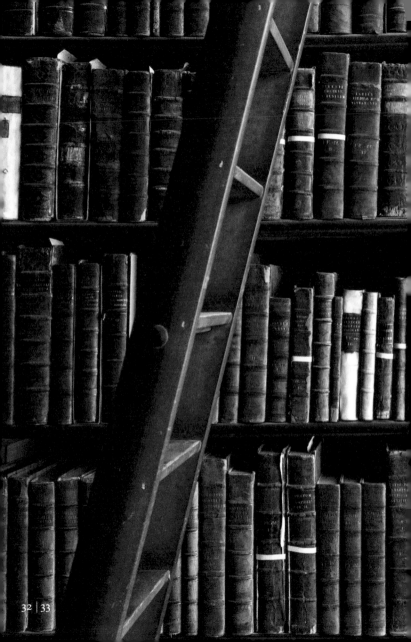

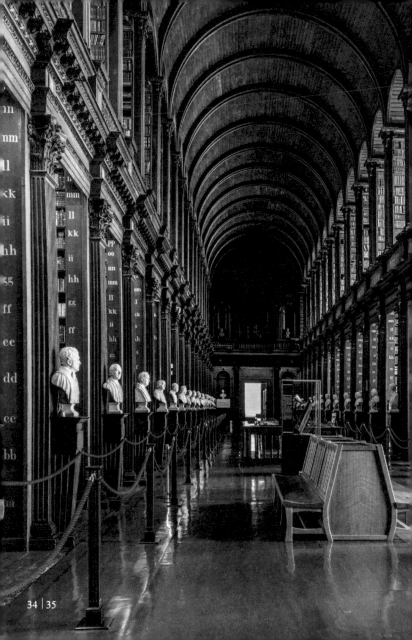

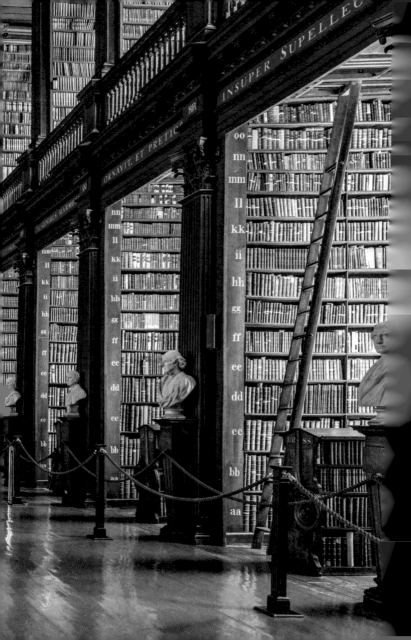

'A library … knows no walls save those of the world itself.'

ERASMUS
Adagia

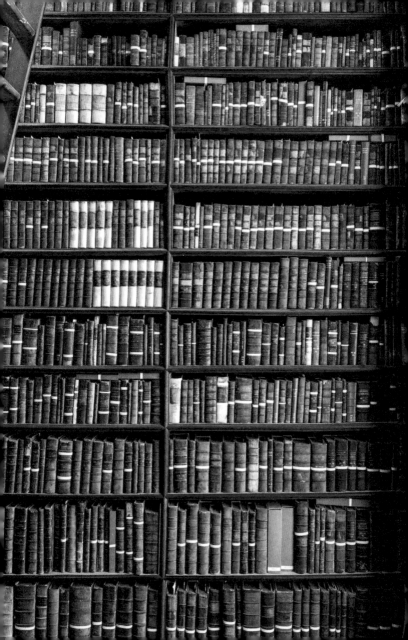

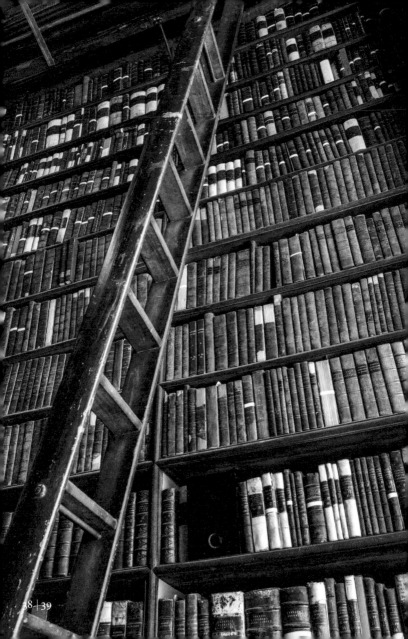

CORRESPONDANCE | CORRESPONDANCE | CORRESPONDANCE | CORRESPONDANCE

DE | DE | DE | DE

NAPOLÉON | NAPOLÉON I. | NAPOLÉON I. | NAPOLÉON

TOME | TOME | TOME | TOME

XX. | XIX. | XVIII. | XVII.

GALL. | GALL. | GALL. | GALL.

MM 38 | MM 38 | MM 38 | MM 38

20 | 19 | 18 | 17.

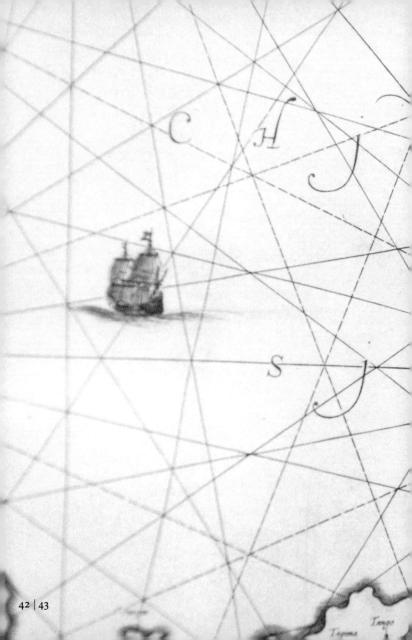

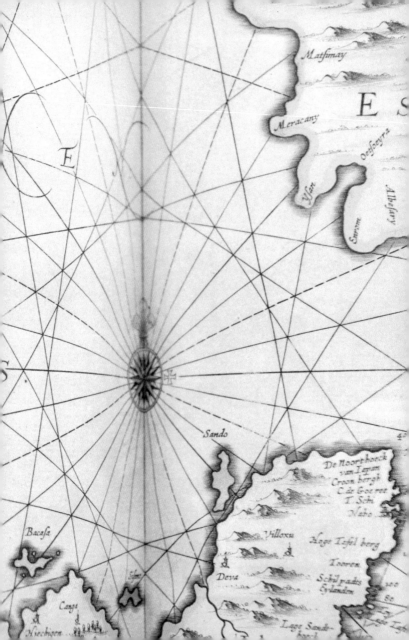

Matfumay

E S

Meracany

Oesfogyra

Vser

Albasey

Sarem

E

S

Sando

40

De Noorthoeck
van Iesso
Croon bergh
C. de Goe ree
T. Schi
Nabo

Bacasa

Villoxu

Hage Tafel berg

Tooren

Deva

Schil padts
Eylanden

Canga

Lage Sand
hoeck

Hiechigon

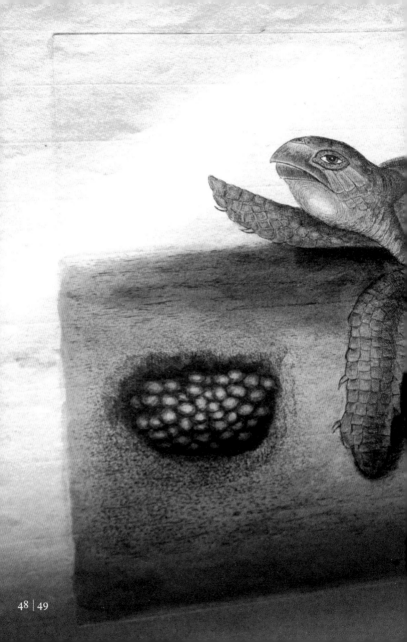

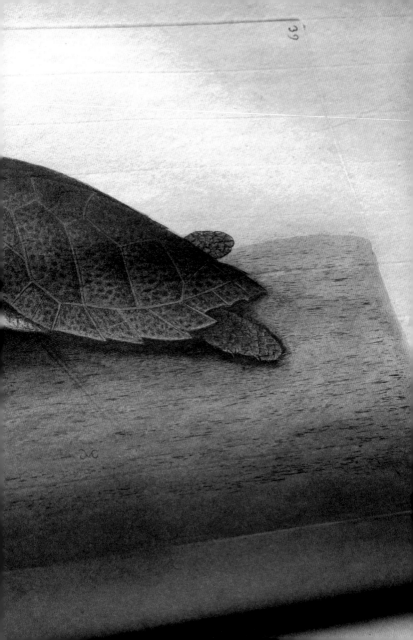

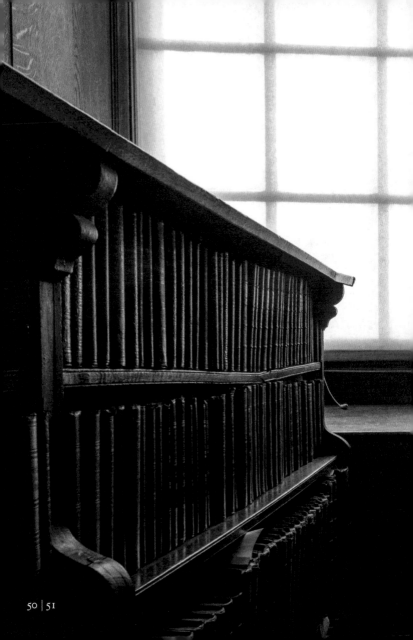

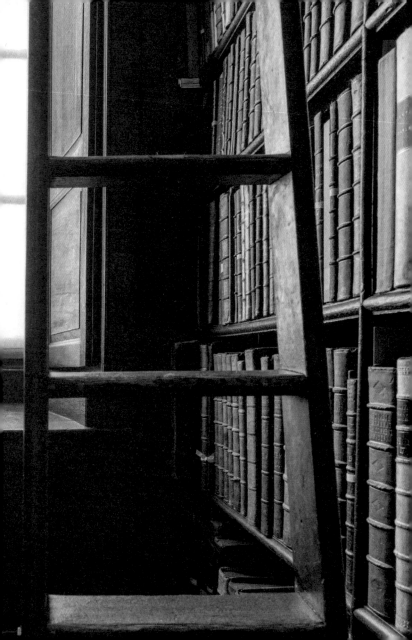

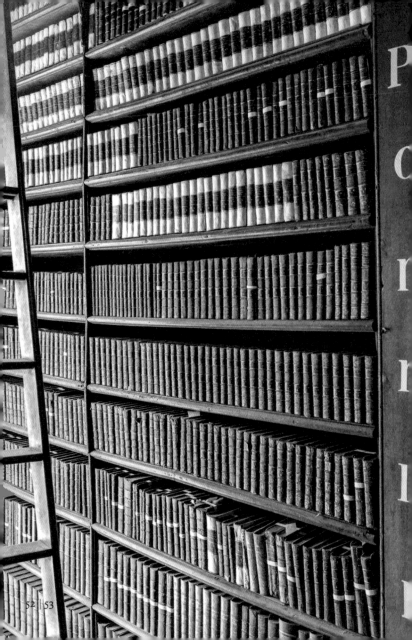

'Knowing I lov'd my books, he furnish'd me / From mine own library with volumes that / I prize above my dukedom.'

WILLIAM SHAKESPEARE

Prospero in *The Tempest*, Act I Scene ii

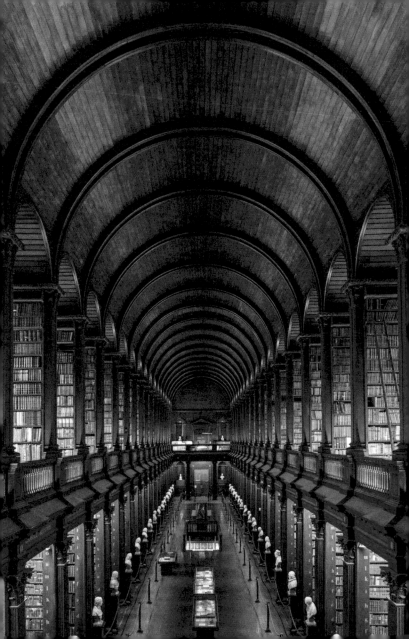

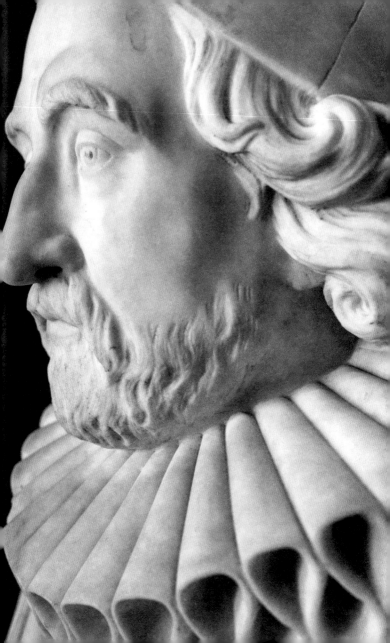

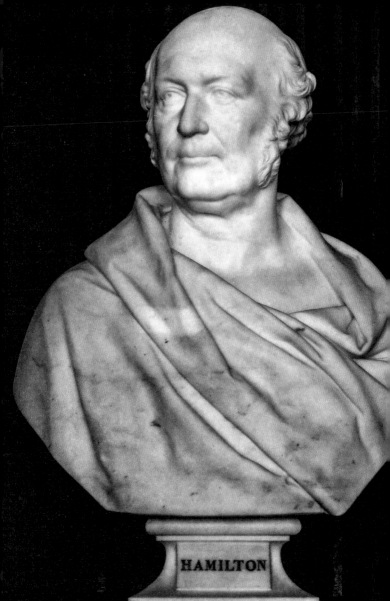

HAMILTON

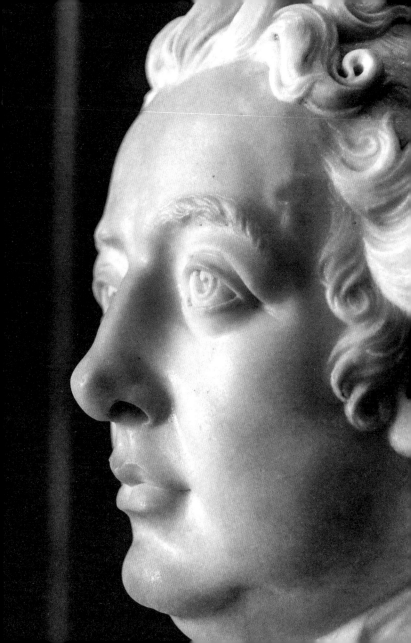

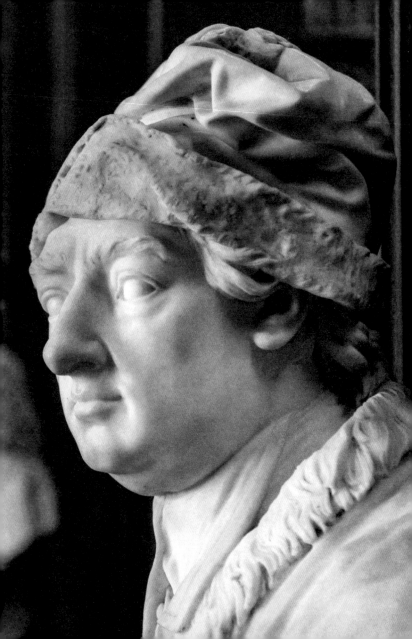

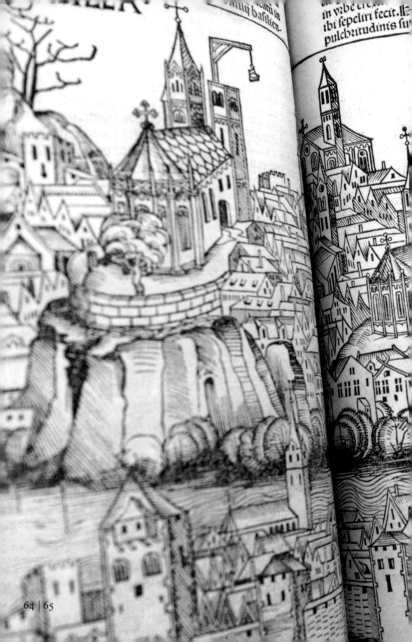
…ath in
…ilij basilien

in vrbe cre…
ibi sepeliri fecit. li…
pulchritudinis su…

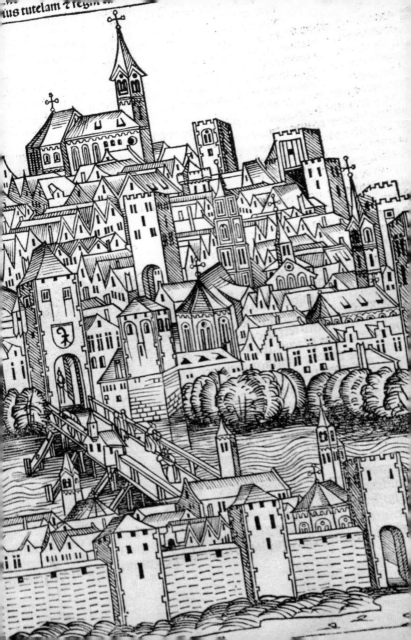

MATH:-NATUR: CLASSE XL. 1882

MATH:-NATUR: CLASSE XXXIX. 1878 - 79.

MATH:-NATUR: CLASSE XXXVIII. 1877-78.

MATH:-NATUR: CLASSE XXX... 1876

GALL. HH. 27. 36.

GALL. HH. 27. 35.

GALL. HH. 27. 34.

GALL. HH. 3...

67 MIT

O FILIOS

S · SVMPTV · SVO

MPLO · FRVE TVR

SVA · PERIERINT

MAGNVM · HAṼD

AGNVS · ESTO

PFII CORP

SILVVS

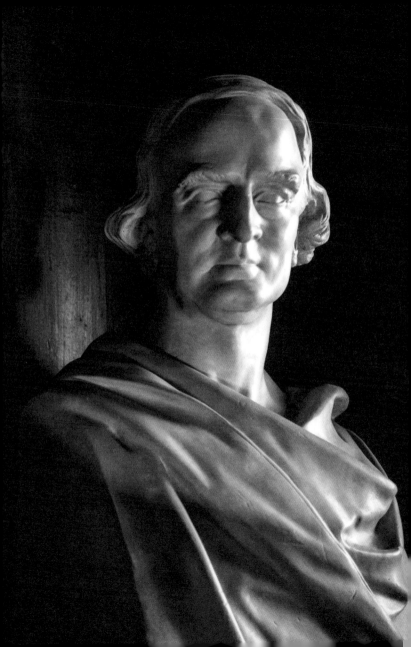

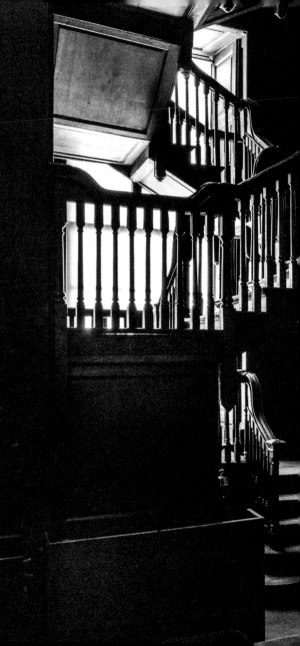

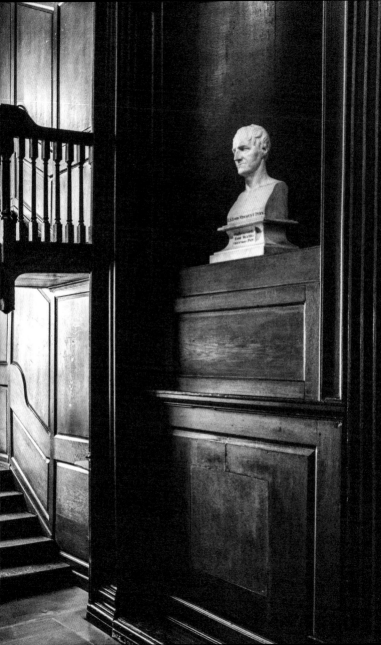

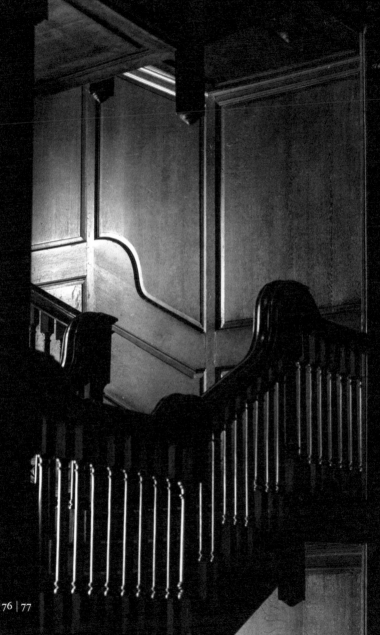

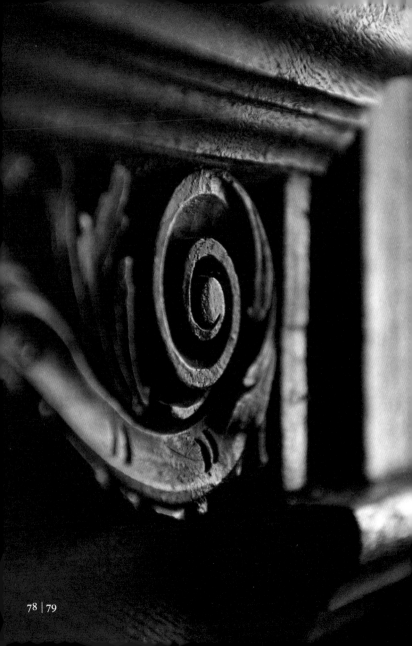

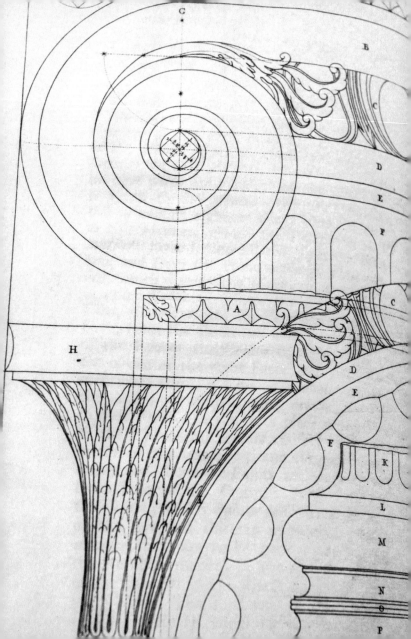

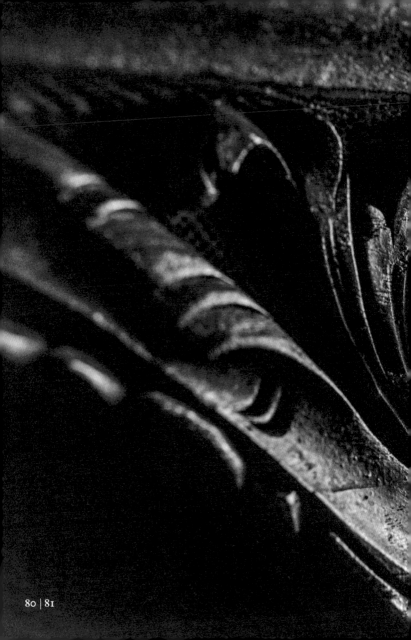

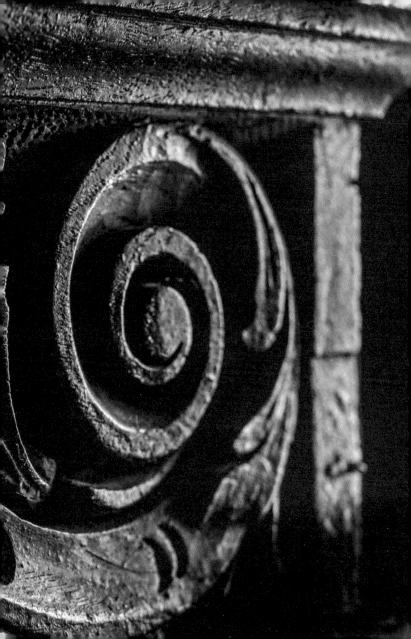

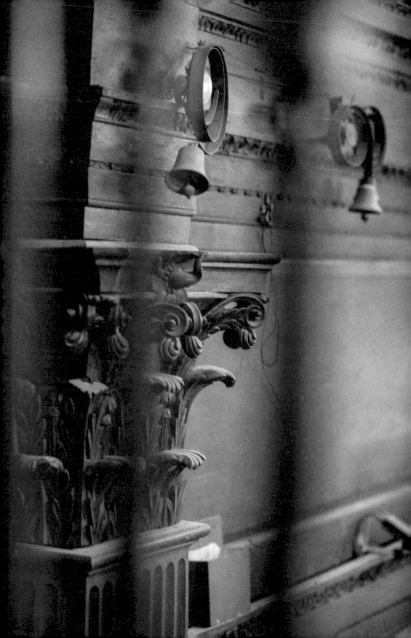

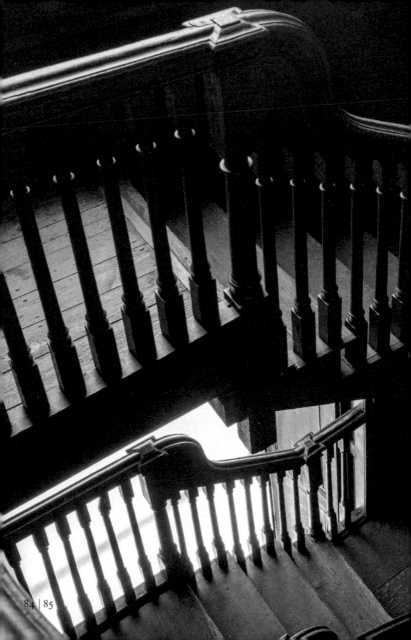

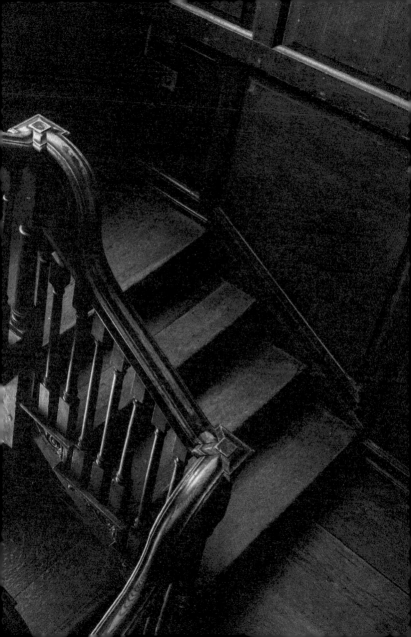

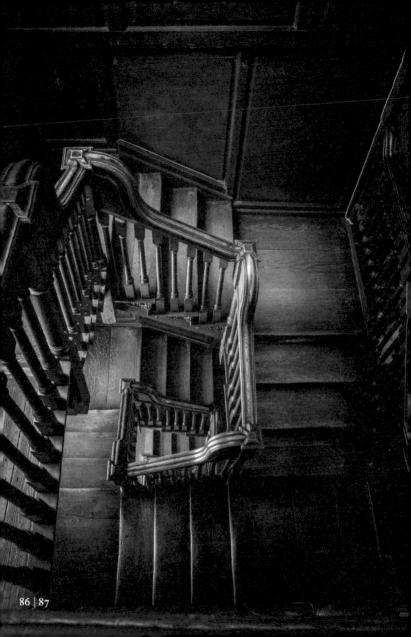

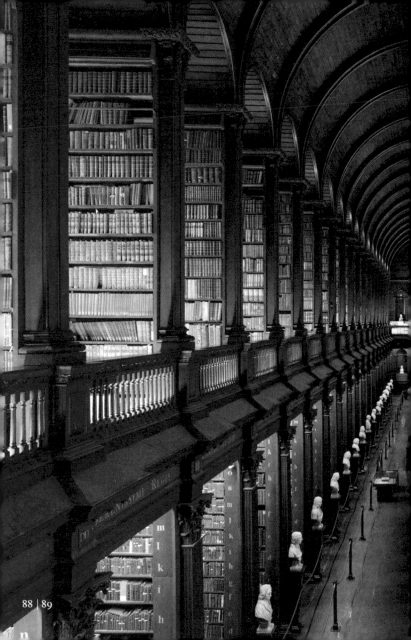

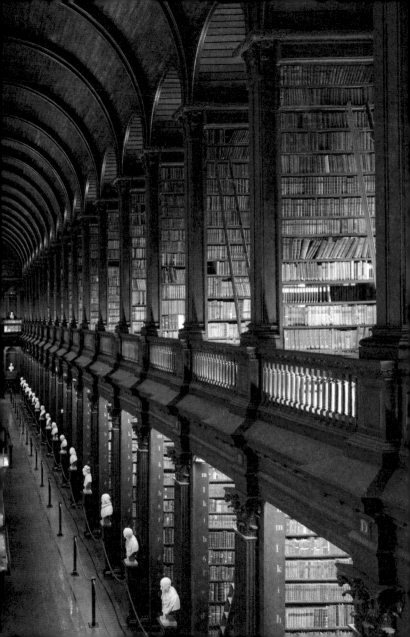

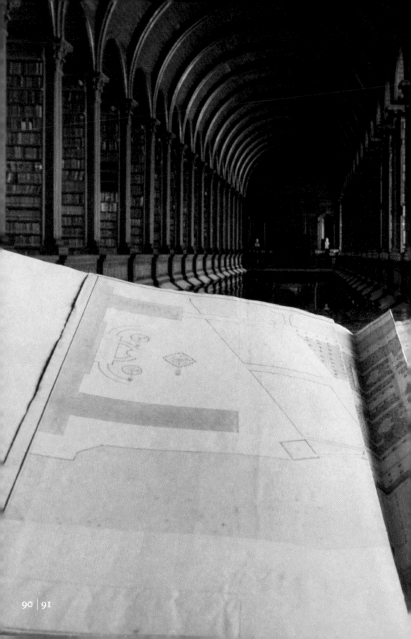

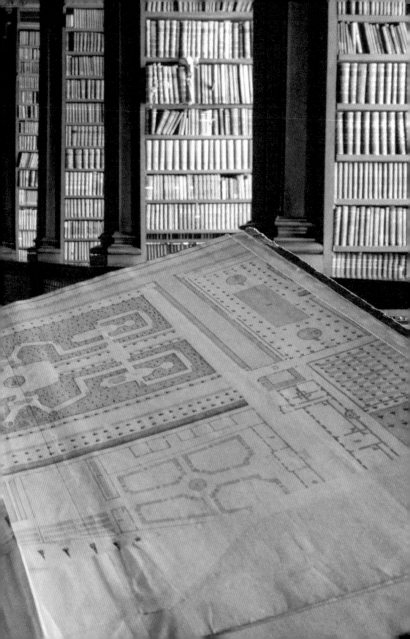

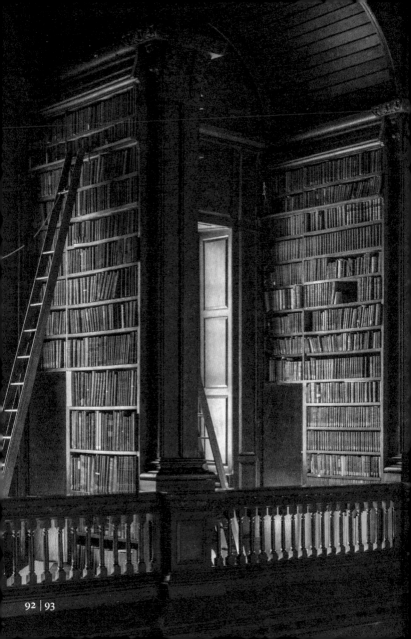

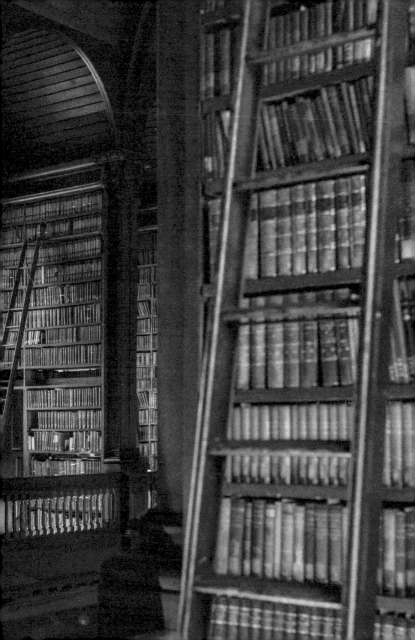

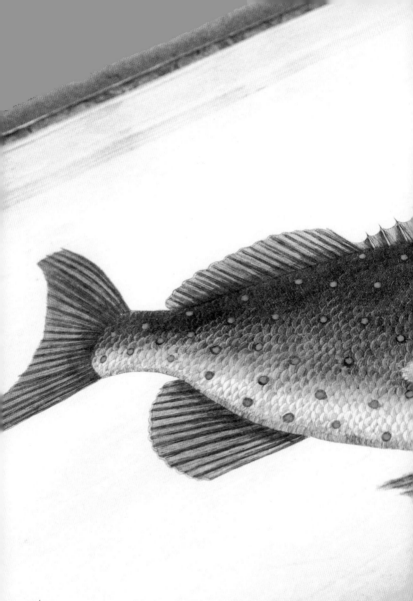

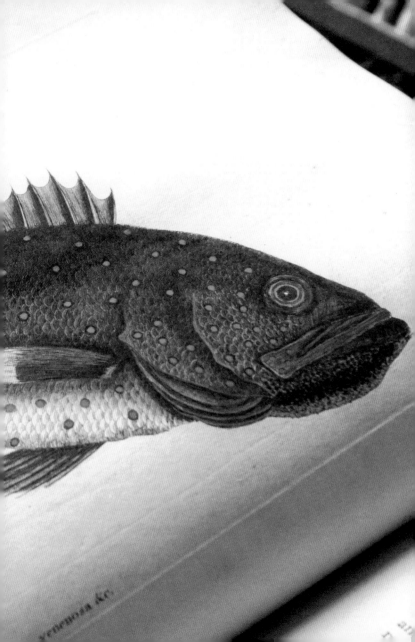

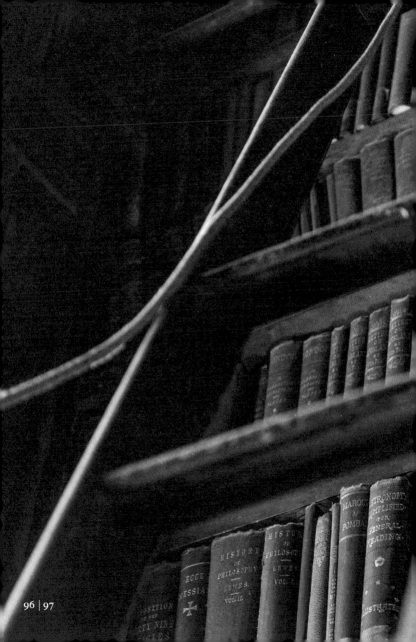

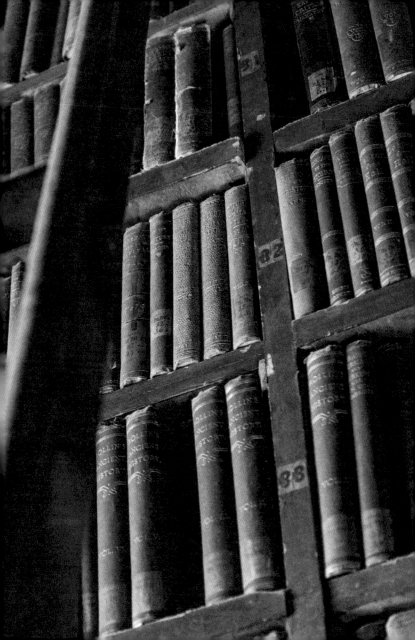

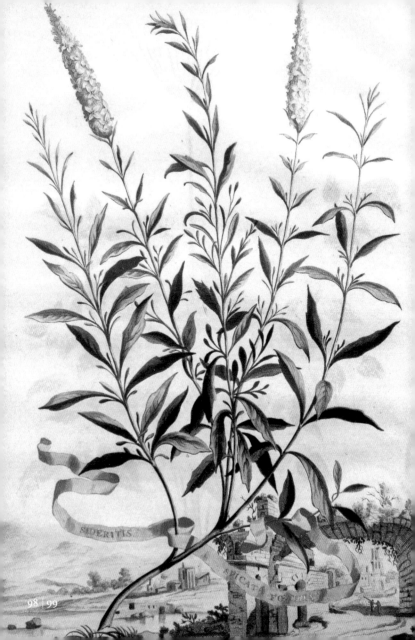

SIDERITIS

SPICATA FŒTIDA

FLORA DANICA

FLORA DANICA

FLORA DANICA

FLORA DANICA

VOL VOL VOL VOL VOL

XI X IX VII VII

12 11 10 9 7

TIONARY
THE
STOLIC
RCH

STINGS
ED.

M . I

ARON-
STRA

ICTIONARY
OF THE
APOSTOLIC
CHURCH

ASTINGS
ED.

VOL . II

MACEDONIA-
ZION

INDEXES

ELEMENTS
OF
MATERIA MEDIC
EDITED BY
BENTLEY AND REDWO

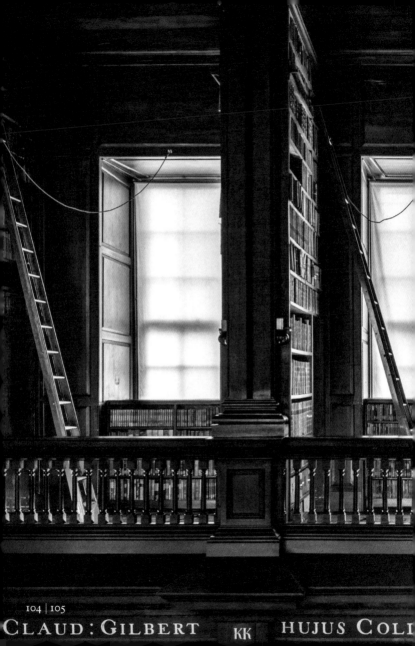

CLAUD:GILBERT KK HUJUS COLL

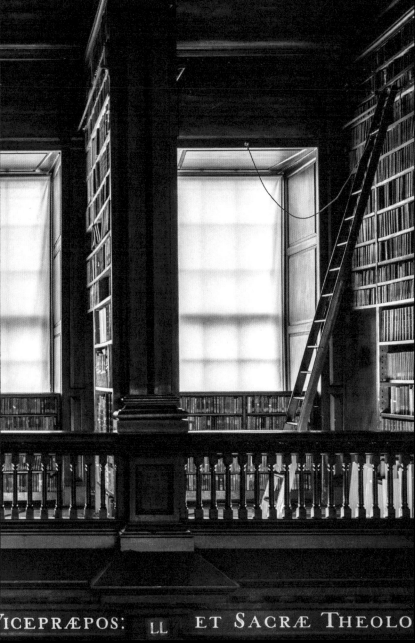

VICEPRÆPOS: LL ET SACRÆ THEOLO

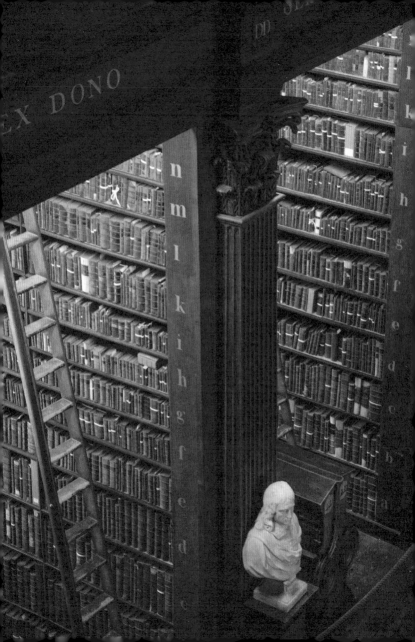

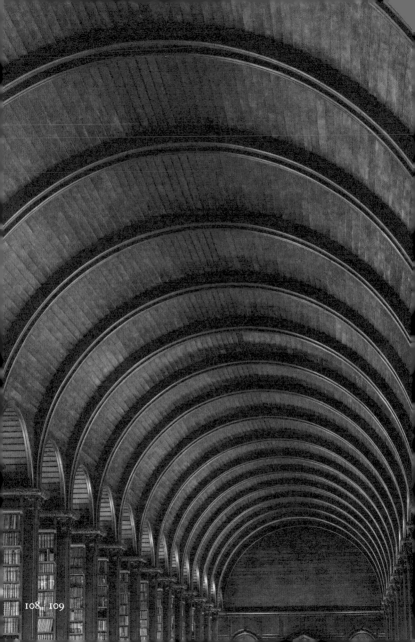

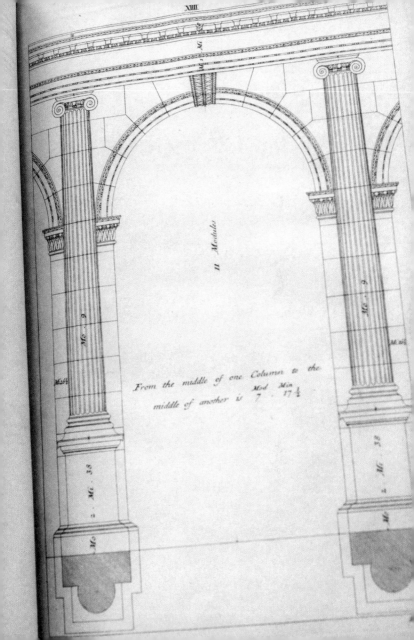

11 Modules

From the middle of one Column to the
middle of another is 7 . 17½ Mod Min

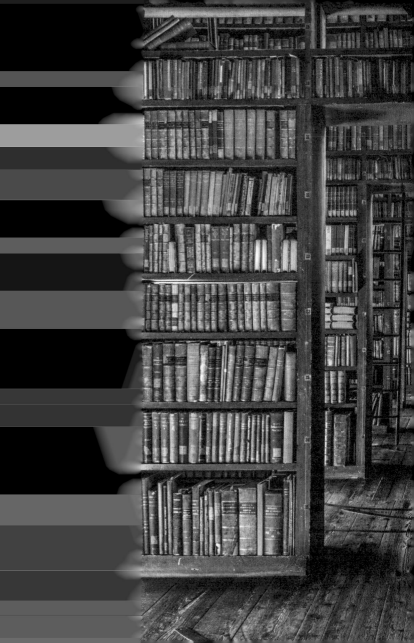

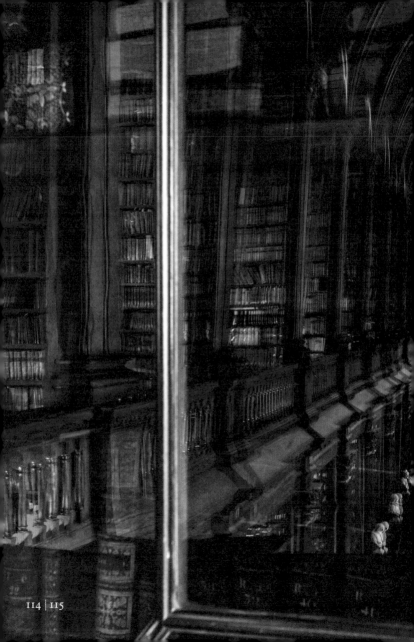

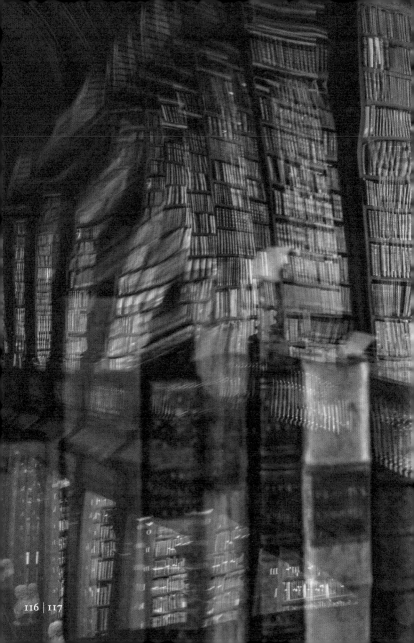

THE
WORLD
GONE
MAD

BY
MARTIAN

Mould, Mrs John
An account of Miss Wood's
development as a medium

Adshead, W P
Miss Wood in Derbyshire, a series of
seances demonstrating the fact that spirits
appear in the physical form, repo...
Adshead. Also an account of
as a medium, by Mrs...
J. ...

pa 54...

MORT

'Books [are] the children
of the brain.'

JONATHAN SWIFT
A Tale of a Tub

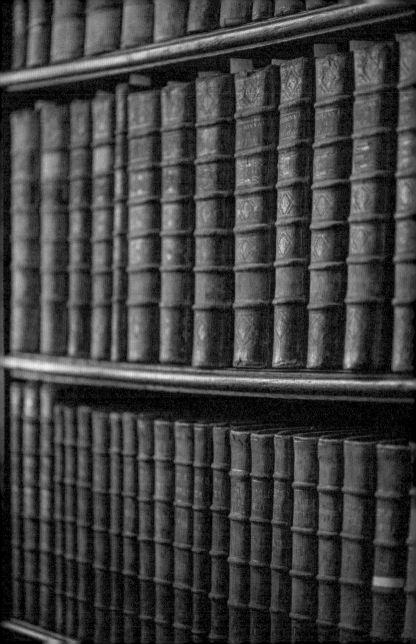

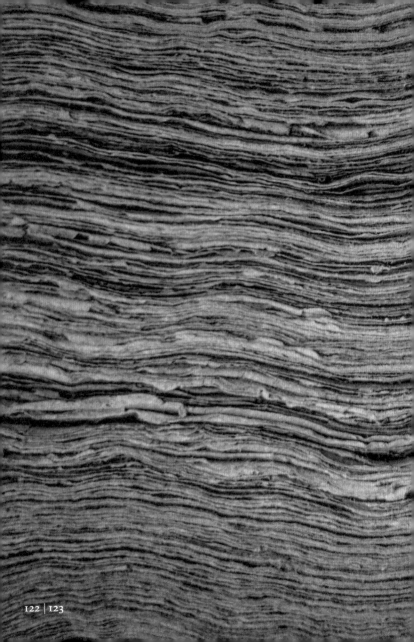

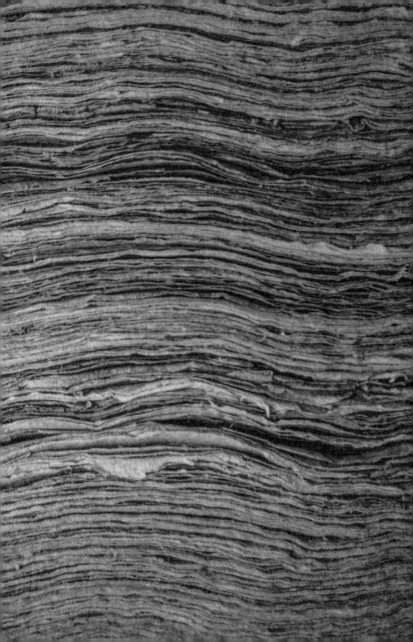

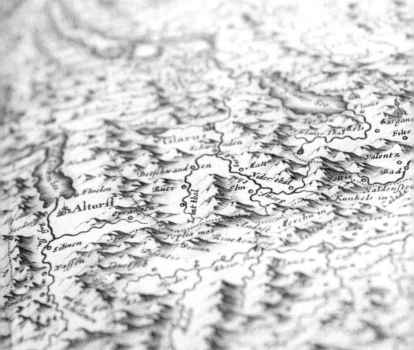

Wurnet

Sar fl.

Enstorf

Roden

rscheit

arlbach

Dallinge

Sursberg

Waldekfeng

Wadegaßn

Hartgarten

Baurains

Zumsstital

Belchen
Broncher

Waldt

Longeville
ab
Teutungen

Suenbiders
torff

Faulquemont

Elbingen

Fledderingen

Nelfingen

Reber

Weyr
flu

E

G

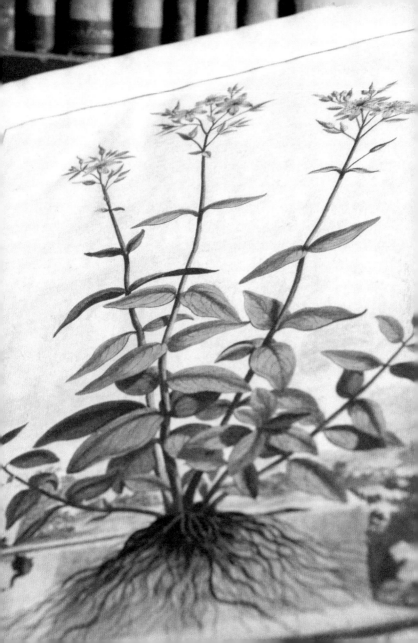

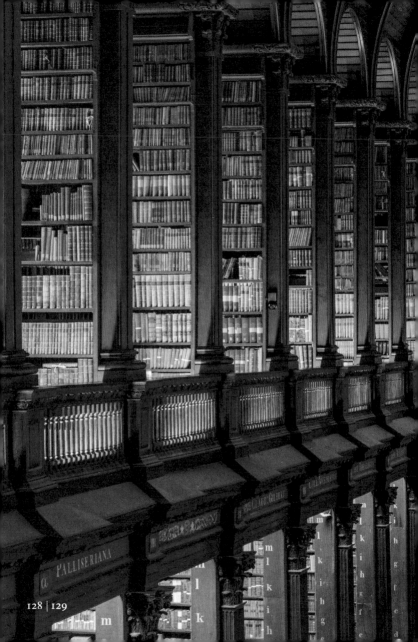

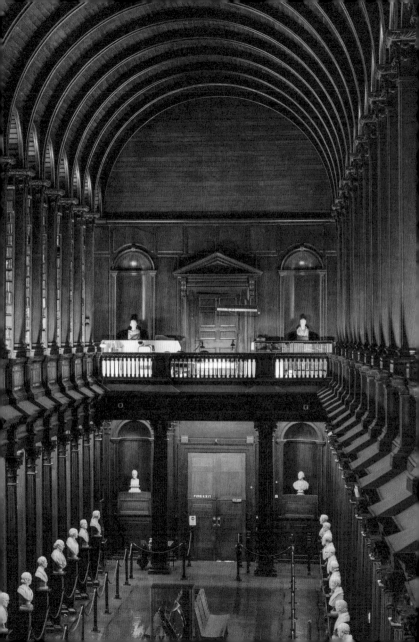

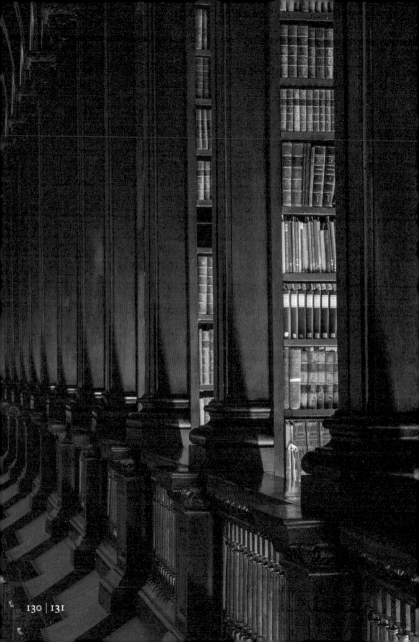

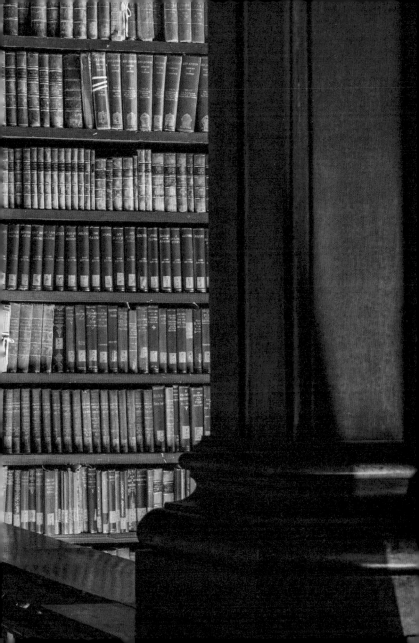

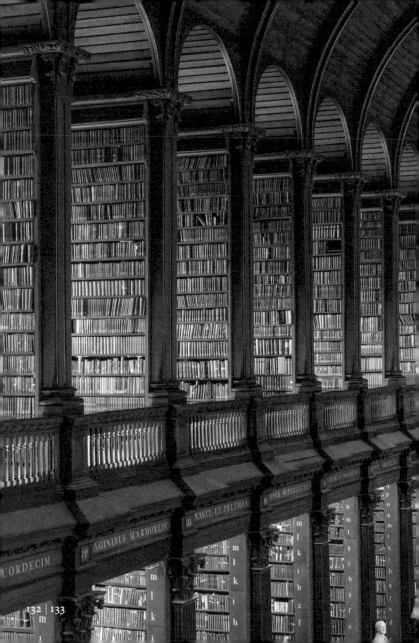

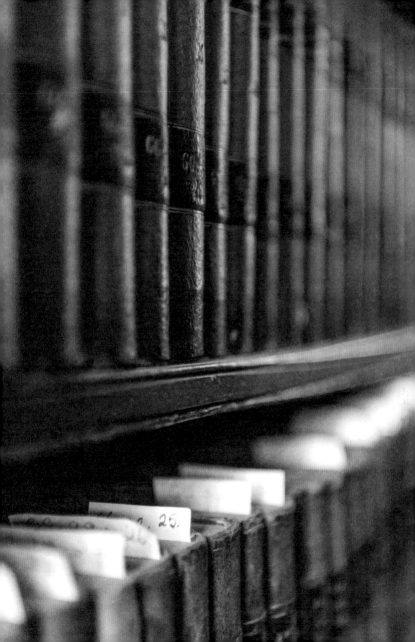

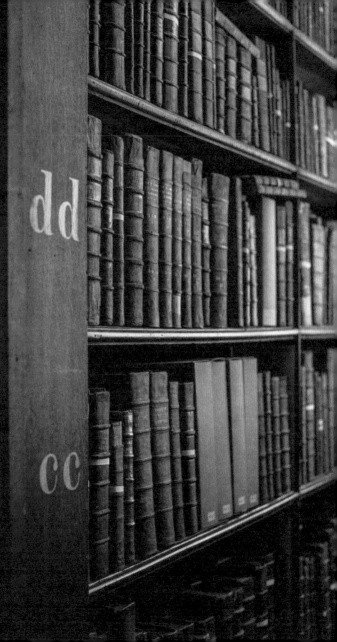

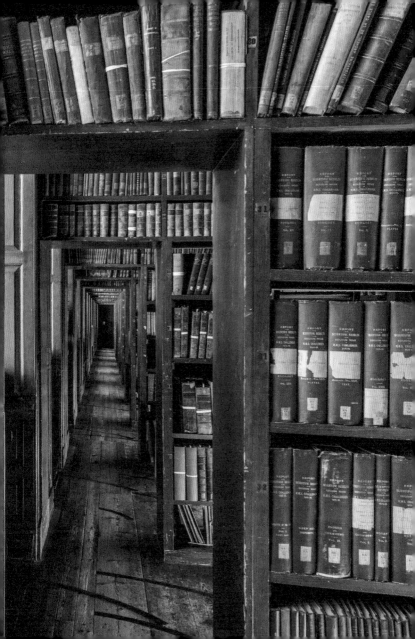

REPORT

of the

EXPLORING VOYAGE

of

H.M.S. CHALLENGER.

1873–76.

PART LIX.
MONAXONIDA.
S. O. RIDLEY AND A. DENDY.

———

PART LXI.
MYZOSTOMIDA.
SUPPLEMENT
L. VON GRAFF.

———

PART LXII.
CEPHALODISCUS
DODECALOPHUS.
W. C. M'INTOSH.

ZOOLOGY.

———

VOL. XX.

I STEPHANAS
AM

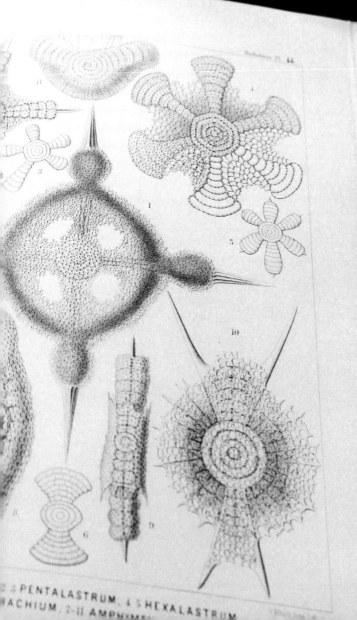

3 PENTALASTRUM, 4 5 HEXALASTRUM
RACHIUM, 7-11 AMPHY...

GALLERY
KK
32.
77

GALLERY
KK
32
76

GALLERY
KK
32
75

GALLERY.
KK
32
74

ERY.

K

32

13

GALLERY.

KK

32

M2

GALLERY.

KK

GALLERY.

GA

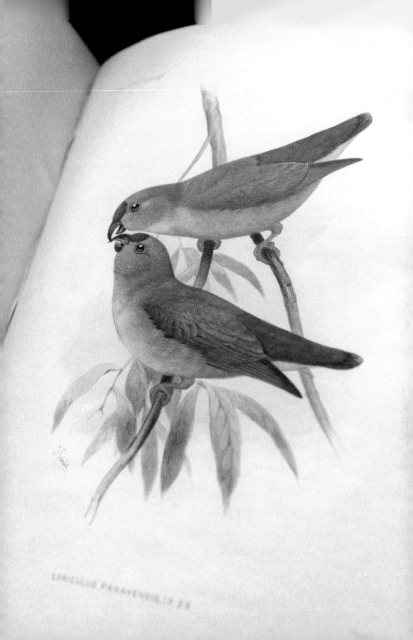

LORICULUS PANAYENSIS ER.

TOWARDS THE MOUNTAINS OF THE MOON

BLACKWOOD & SONS

TOWARDS
THE
MOUNTAINS
OF THE
MOON

DUBLIN
GAZETTE

DUBLIN
GAZETTE

DUBLIN
GAZETTE

1758-60

1764-66

DUBLIN
GAZETTE

DUBLIN
GAZETT

DUBLIN
GAZETTE

1770-71

1772-7

DEC. 1767-
DEC. 1769

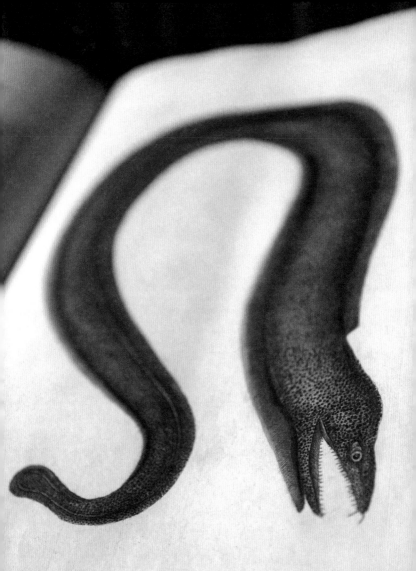

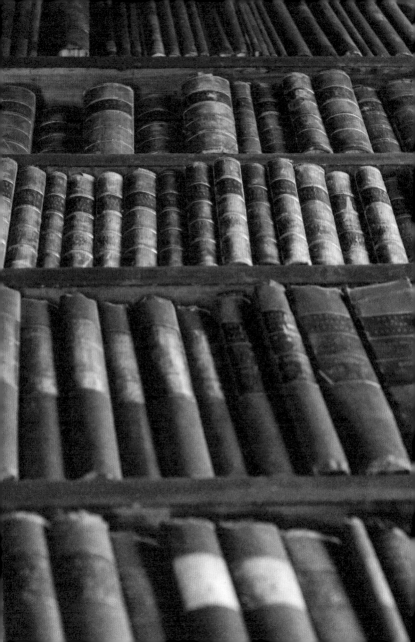

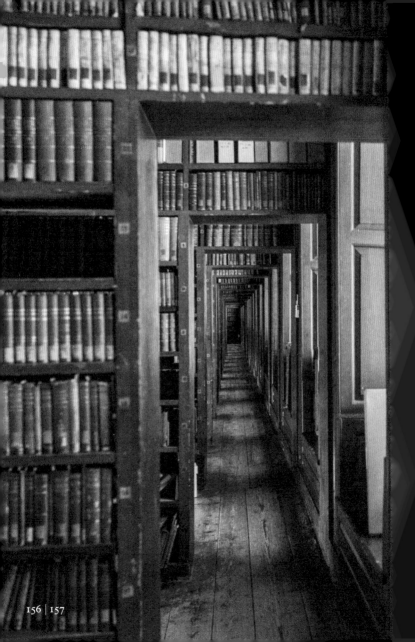

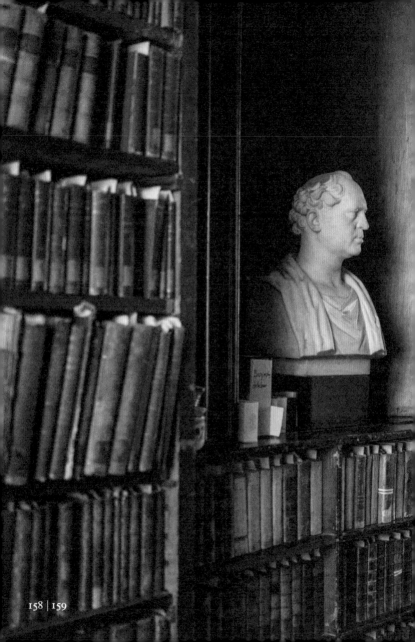

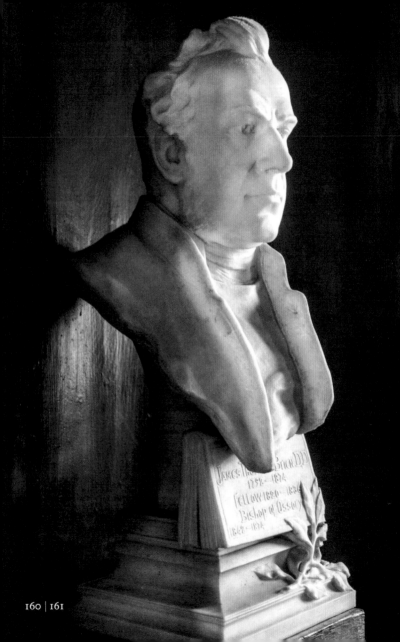

James Thomas O'Brien D.D.
1792–1874
Fellow 1820–1836
Bishop of Ossory
1842–1874

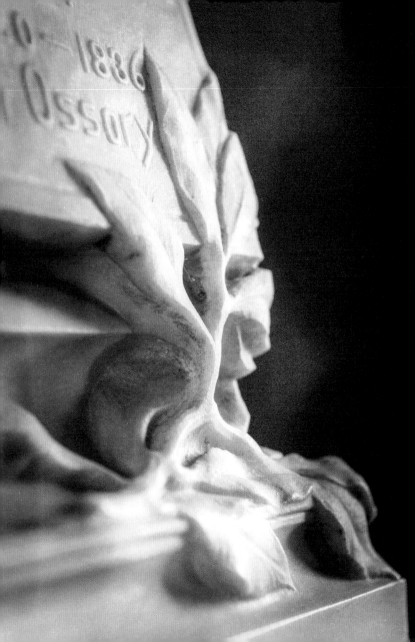

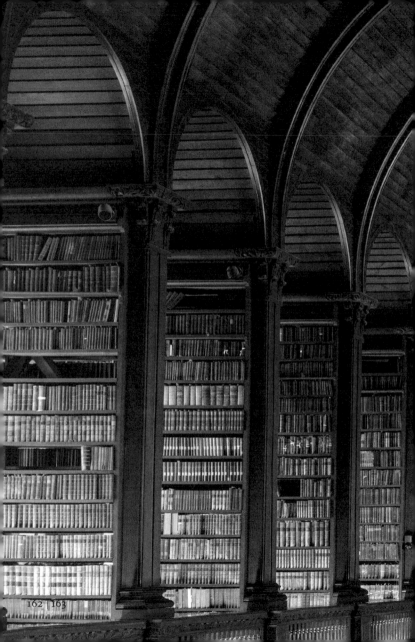

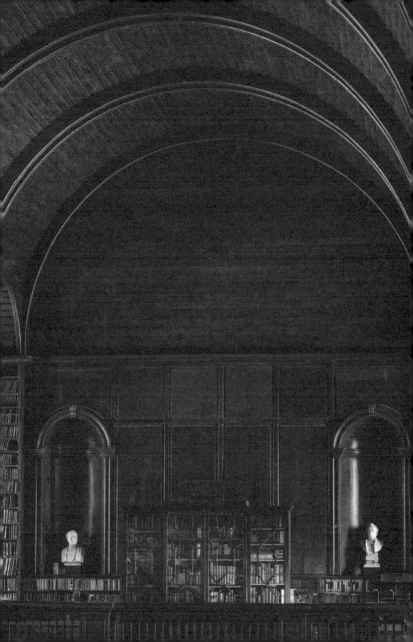

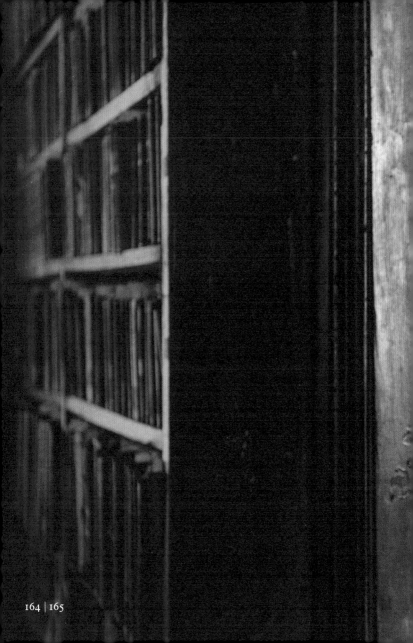

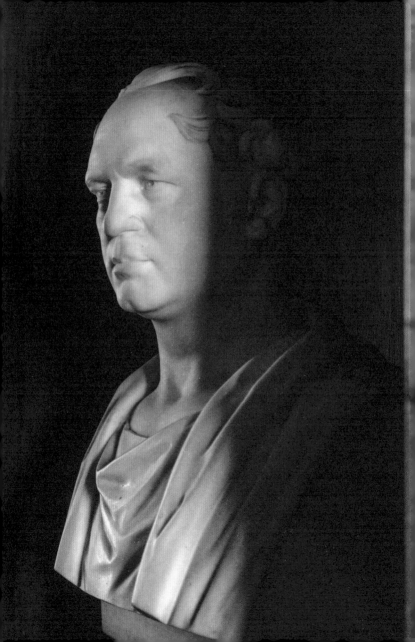

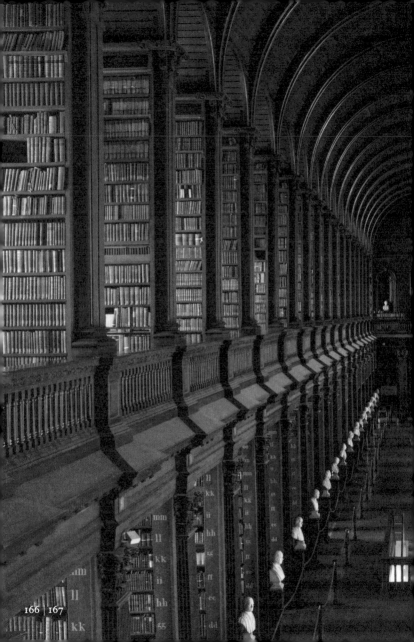

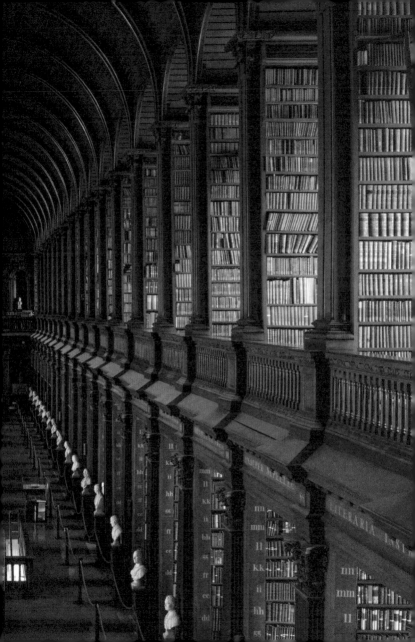

CAPTIONS

The following busts in the Long Room collection are reproduced:

Frontispiece and pages 60–61: Jonathan Swift (1667–1745; writer and cleric; author of *Gulliver's Travels*; alumnus of Trinity College Dublin) by Louis-François Roubiliac (1702–1762)

Pages 18–19: James Whiteside (1804–1876; Irish politician and judge; alumnus of Trinity College Dublin) by Patrick MacDowell (1799–1870)

Page 20: Socrates (*c.* 470–399 BC) by Peter Scheemakers (1691–1781)

Page 21: Patrick Delany (1686–1768; cleric; alumnus of Trinity College Dublin) by John van Nost the younger (1713–1780)

Page 22: Cicero (106–43 BC) by Peter Scheemakers

Pages 56–57: James Ussher (1581–1656; Archbishop of Armagh and Primate of All Ireland; alumnus of Trinity College Dublin) by Peter Scheemakers

Page 58: William Rowan Hamilton (1805–1865; mathematician, astronomer and physicist; alumnus of Trinity College Dublin) by John Henry Foley (1818–1874)

Page 59: Thomas Parnell (1679–1718; poet and cleric; alumnus of Trinity College Dublin) by Edward Smyth (1749–1812)

Pages 72–73: John Adam Malet (1810–1879; Librarian, Trinity College Dublin, 1869–79) by John Edward Jones (1806–1862)

THE LIBRARY OF TRINITY COLLEGE DUBLIN: A BRIEF HISTORY

1592

Founding of Trinity College Dublin (officially, the College of the Holy and Undivided Trinity of Queen Elizabeth near Dublin) by Queen Elizabeth I.

1661

The Book of Kells, a beautifully decorated manuscript of the four Gospels dating from about 800 and now widely regarded as Ireland's greatest cultural treasure, is presented to Trinity College Dublin. It has been on display in what is now called the Old Library since the 19th century.

1712–32

Construction of the Old Library building, to designs by Irish architect Thomas Burgh (also known as Thomas de Burgh; 1670–1730), creating Library Square to the north and Fellows' Square to the south.

1743

The first marble busts that line the Long Room are commissioned from Flemish sculptor Peter Scheemakers (1691–1781), who was living and working in London. Subjects – all men – include great philosophers and writers, among them Aristotle, Cicero, Homer, Plato, Socrates, Francis Bacon, Robert Boyle, John Milton, Isaac Newton and William Shakespeare. Later busts include one of Thomas Parnell by

Irish sculptor Edward Smyth (1749–1812) and one of Jonathan Swift by London-based French sculptor Louis-François Roubiliac (1702–1762).

1801
The Library at Trinity College Dublin is made one of six legal deposit libraries in the United Kingdom and Ireland, entitling it to receive, free of charge, a copy of every book published in both territories. As a result, the library's collection quickly expands.

1860–61
The flat plaster ceiling of the Long Room, the main chamber within the Old Library, is raised to accommodate the upper-gallery bookcases and the wooden barrel-vaulted ceiling.

Today, the Old Library houses around 200,000 of Trinity College Dublin's rarest volumes and an extensive collection of early manuscripts.

The entire library at Trinity College houses more than 6.2 million volumes, making it the largest library in Ireland.

ACKNOWLEDGMENTS

Harry Cory Wright and Helen Shenton are grateful to the following for their invaluable help with this book: Susie Bioletti, Pat Comerford and all the library security guards, Anne-Marie Diffley, Lydia Ferguson, Peter Fox, Peter Gallagher, Simon Lang, Shane Mawe, Edward McParland and Michael Nason. Helen Shenton is particularly indebted to Peter Fox, author of *Trinity College Library Dublin: A History* (Cambridge University Press, 2014).

First published in the United Kingdom in 2018 by Thames & Hudson Ltd, 181A High Holborn, London WC1V 7QX

The Library of Trinity College Dublin © 2018 Thames & Hudson Ltd, London

Photographs by Harry Cory Wright © Thames & Hudson Ltd and The Board of Trinity College, the University of Dublin

Introduction by Helen Shenton © 2018 The Board of Trinity College, the University of Dublin

Series book design by Peter Dawson, gradedesign.com

British Library Cataloguing-in-Publication Data
A catalogue record for this book is available from the British Library

ISBN 978-0-500-29459-8

Printed and bound in China by C&C Offset Printing Co. Ltd

To find out about all our publications, please visit
www.thamesandhudson.com. There you can subscribe to our e-newsletter, browse or download our current catalogue, and buy any titles that are in print.